In The Bush

Debjani Sengupta

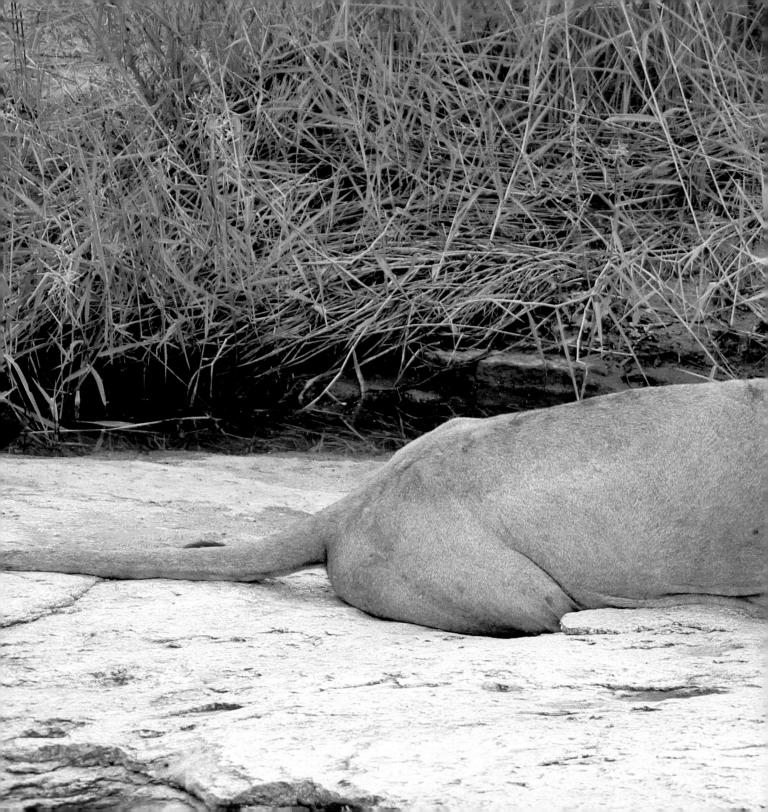

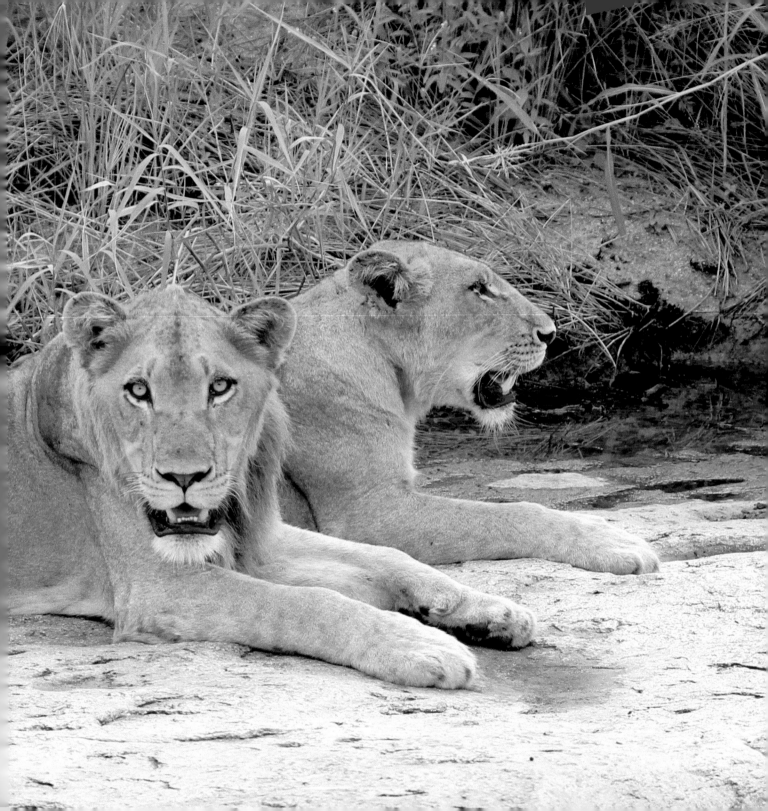

AuthorHouse™ UK
1663 Liberty Drive
Bloomington, IN 47403 USA
www.authorhouse.co.uk
Phone: 0800 047 8203 (Domestic TFN)
+44 1908 723714 (International)

Resource
krugerpark.co.za
southafrica.co.za
wildlifesouthafrica.com
nature-reserve.co.za
elephantlisteningproject.org
researchgate.net
livescience.com
sciencedaily.com
worldwildlife.org
natgeokids.com
nationalgeographic.co

Because of the dynamic nature of the Internet, any web addresses or links contained in this book may have changed since publication and may no longer be valid. The views expressed in this work are solely those of the author and do not necessarily reflect the views of the publisher, and the publisher hereby disclaims any responsibility for them.

This book is printed on acid-free paper.

ISBN: 978-1-7283-9431-2 (sc)
ISBN: 978-1-7283-9430-5 (e)

Print information available on the last page.

Published by AuthorHouse 01/24/2020

authorHOUSE®

In the Bush
By Debjani Sengupta

Dedication

This book is for my daughter, *Debodhonyaa,* who has befriended animals since she was a year old and who took me to see the bush.

Introduction

This is a photo book of animals who live in the wild in their natural habitat. The photographs were taken without harming the animals in any way. Due to tourism the conservation of these animals is being encouraged as people see them, grow to love them and thus develop empathy for them. Due to easier publication methods the love and admiration for these majestic creatures are crossing more borders as more people can share their experiences. This book looks to foster support for the conservation of wildlife animals.

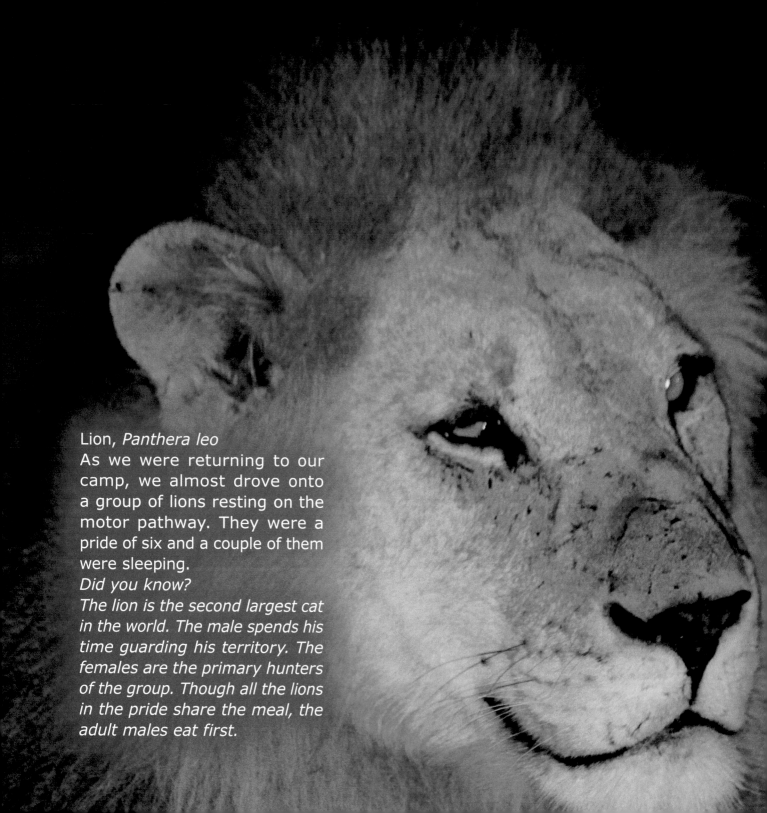

Lion, *Panthera leo*
As we were returning to our camp, we almost drove onto a group of lions resting on the motor pathway. They were a pride of six and a couple of them were sleeping.
Did you know?
The lion is the second largest cat in the world. The male spends his time guarding his territory. The females are the primary hunters of the group. Though all the lions in the pride share the meal, the adult males eat first.

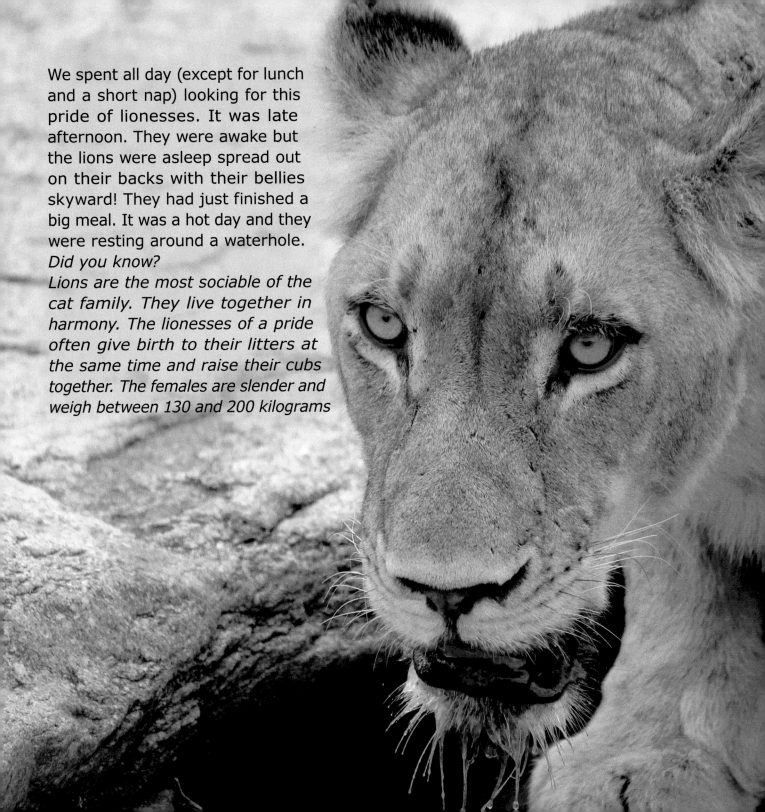

We spent all day (except for lunch and a short nap) looking for this pride of lionesses. It was late afternoon. They were awake but the lions were asleep spread out on their backs with their bellies skyward! They had just finished a big meal. It was a hot day and they were resting around a waterhole.

Did you know?

Lions are the most sociable of the cat family. They live together in harmony. The lionesses of a pride often give birth to their litters at the same time and raise their cubs together. The females are slender and weigh between 130 and 200 kilograms

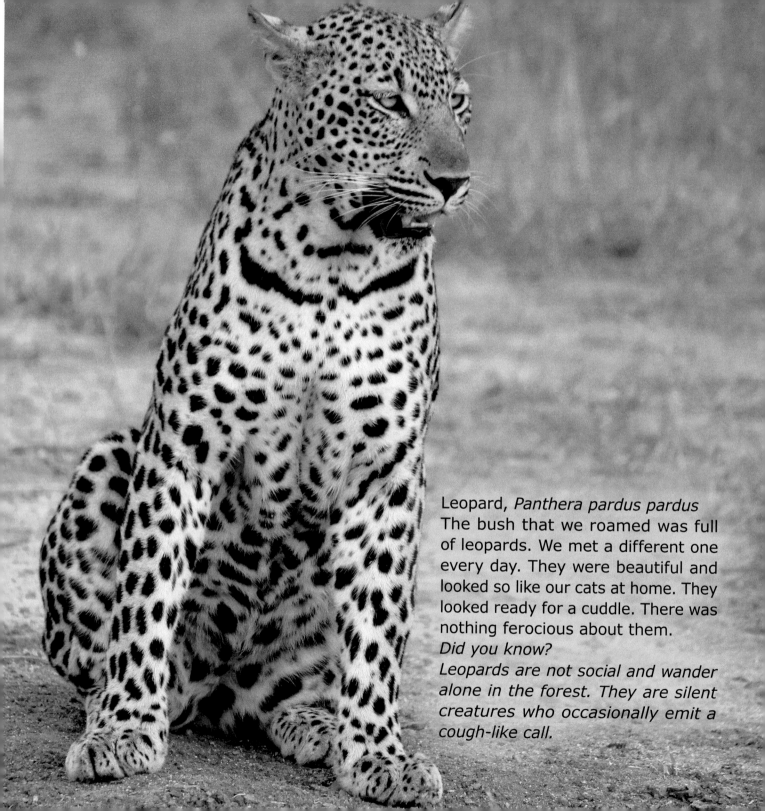

Leopard, *Panthera pardus pardus*
The bush that we roamed was full of leopards. We met a different one every day. They were beautiful and looked so like our cats at home. They looked ready for a cuddle. There was nothing ferocious about them.
Did you know?
Leopards are not social and wander alone in the forest. They are silent creatures who occasionally emit a cough-like call.

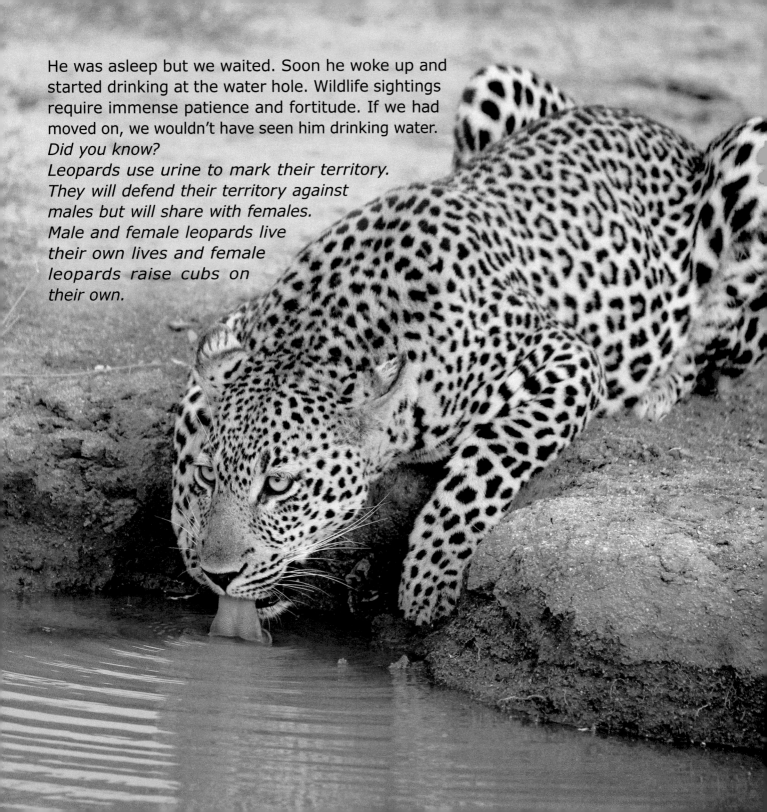

He was asleep but we waited. Soon he woke up and started drinking at the water hole. Wildlife sightings require immense patience and fortitude. If we had moved on, we wouldn't have seen him drinking water.

Did you know?
Leopards use urine to mark their territory.
They will defend their territory against
males but will share with females.
Male and female leopards live
their own lives and female
leopards raise cubs on
their own.

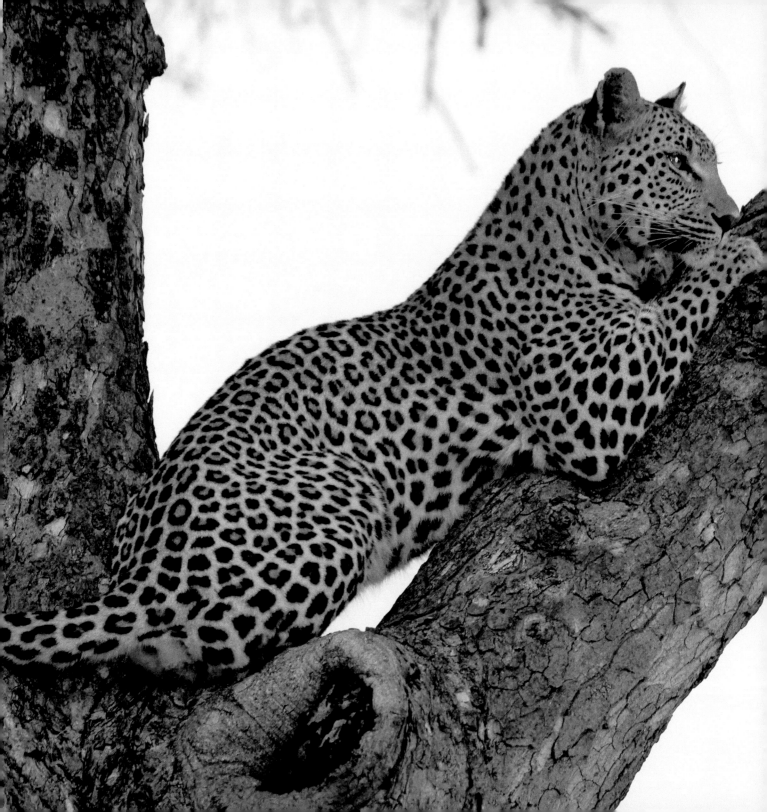

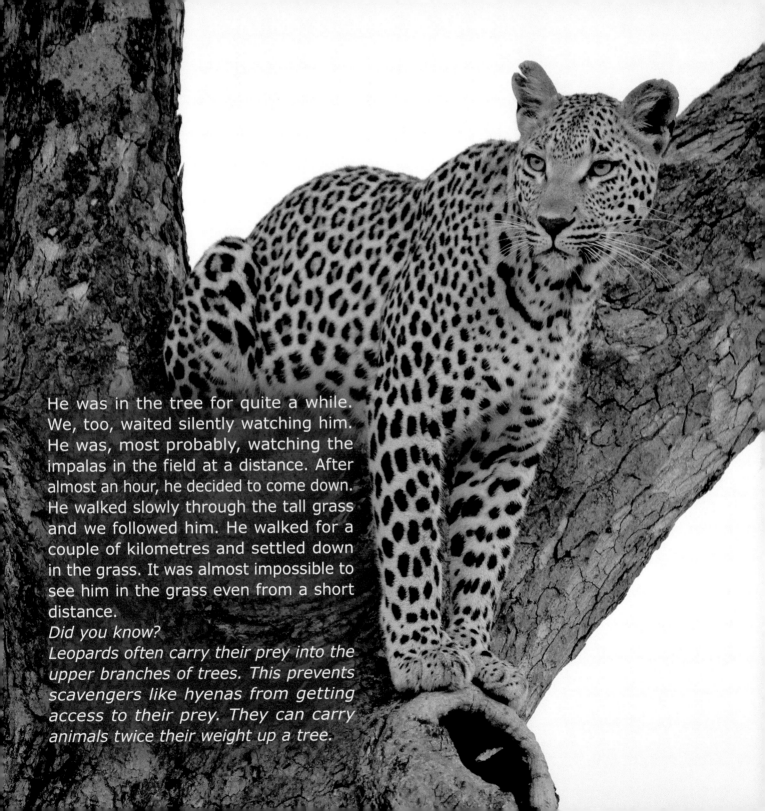

He was in the tree for quite a while. We, too, waited silently watching him. He was, most probably, watching the impalas in the field at a distance. After almost an hour, he decided to come down. He walked slowly through the tall grass and we followed him. He walked for a couple of kilometres and settled down in the grass. It was almost impossible to see him in the grass even from a short distance.

Did you know?
Leopards often carry their prey into the upper branches of trees. This prevents scavengers like hyenas from getting access to their prey. They can carry animals twice their weight up a tree.

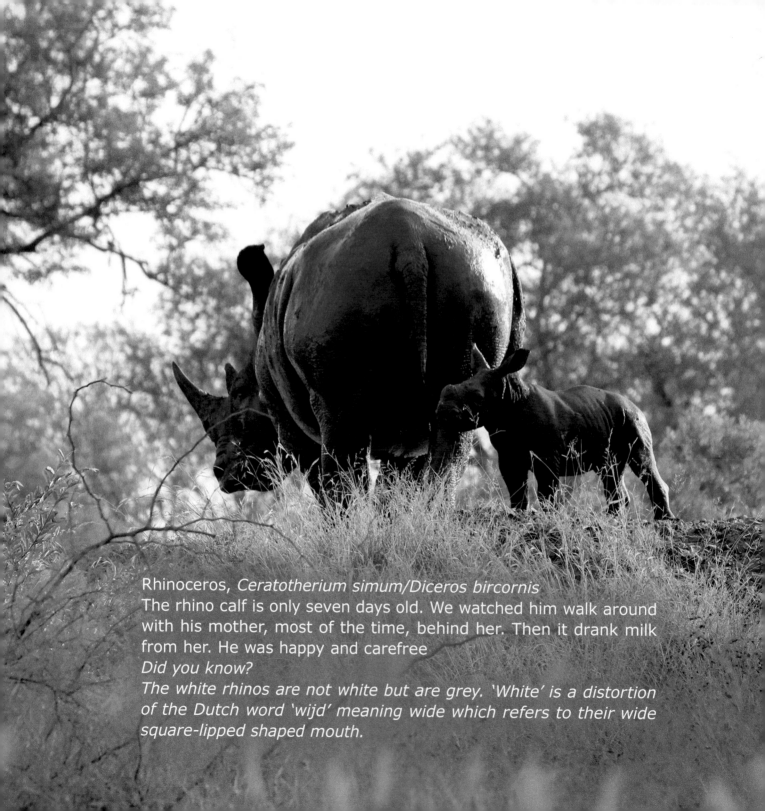

Rhinoceros, *Ceratotherium simum/Diceros bircornis*
The rhino calf is only seven days old. We watched him walk around with his mother, most of the time, behind her. Then it drank milk from her. He was happy and carefree
Did you know?
The white rhinos are not white but are grey. 'White' is a distortion of the Dutch word 'wijd' meaning wide which refers to their wide square-lipped shaped mouth.

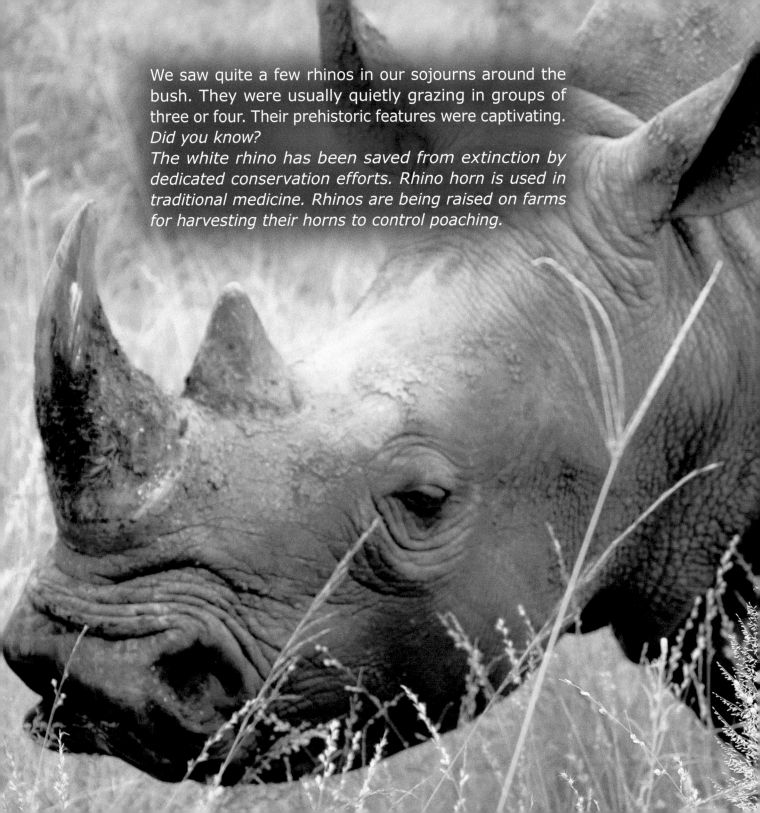

We saw quite a few rhinos in our sojourns around the bush. They were usually quietly grazing in groups of three or four. Their prehistoric features were captivating.
Did you know?
The white rhino has been saved from extinction by dedicated conservation efforts. Rhino horn is used in traditional medicine. Rhinos are being raised on farms for harvesting their horns to control poaching.

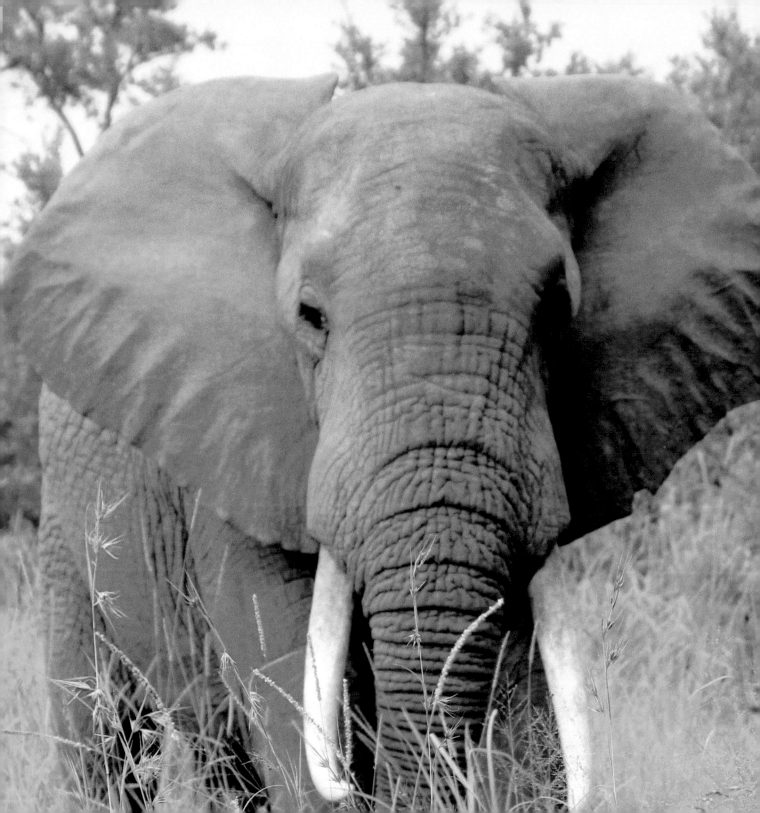

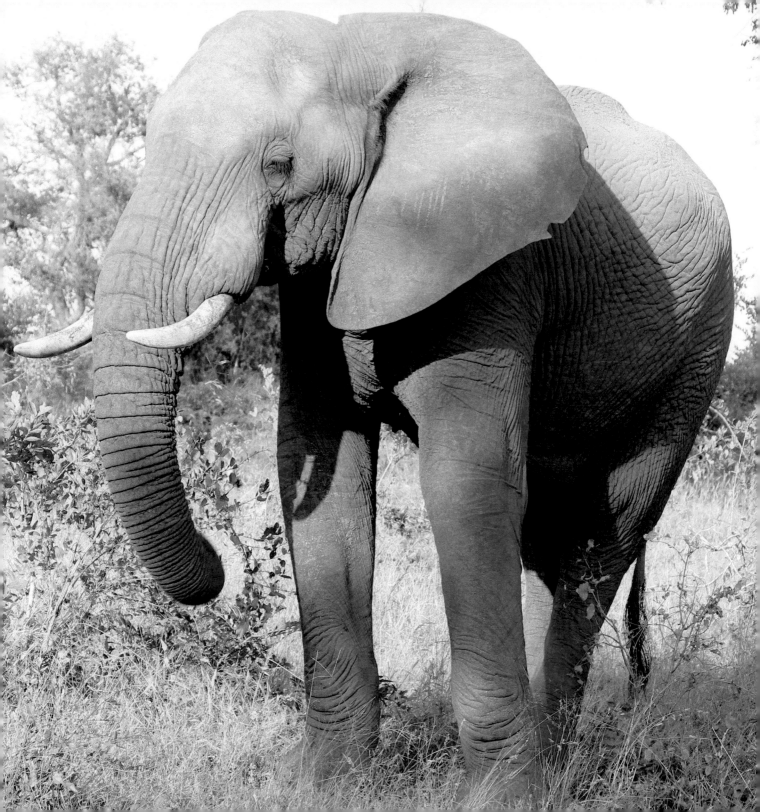

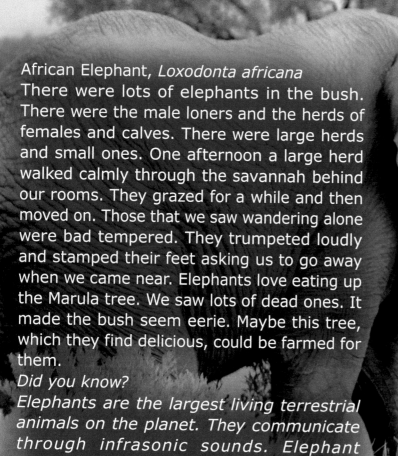

African Elephant, *Loxodonta africana*
There were lots of elephants in the bush. There were the male loners and the herds of females and calves. There were large herds and small ones. One afternoon a large herd walked calmly through the savannah behind our rooms. They grazed for a while and then moved on. Those that we saw wandering alone were bad tempered. They trumpeted loudly and stamped their feet asking us to go away when we came near. Elephants love eating up the Marula tree. We saw lots of dead ones. It made the bush seem eerie. Maybe this tree, which they find delicious, could be farmed for them.

Did you know?
Elephants are the largest living terrestrial animals on the planet. They communicate through infrasonic sounds. Elephant communication can travel long distances and cannot be heard by humans. Their rumbles are deep and powerful. Rhinoceros and giraffes, too, communicate through infrasonic sounds.

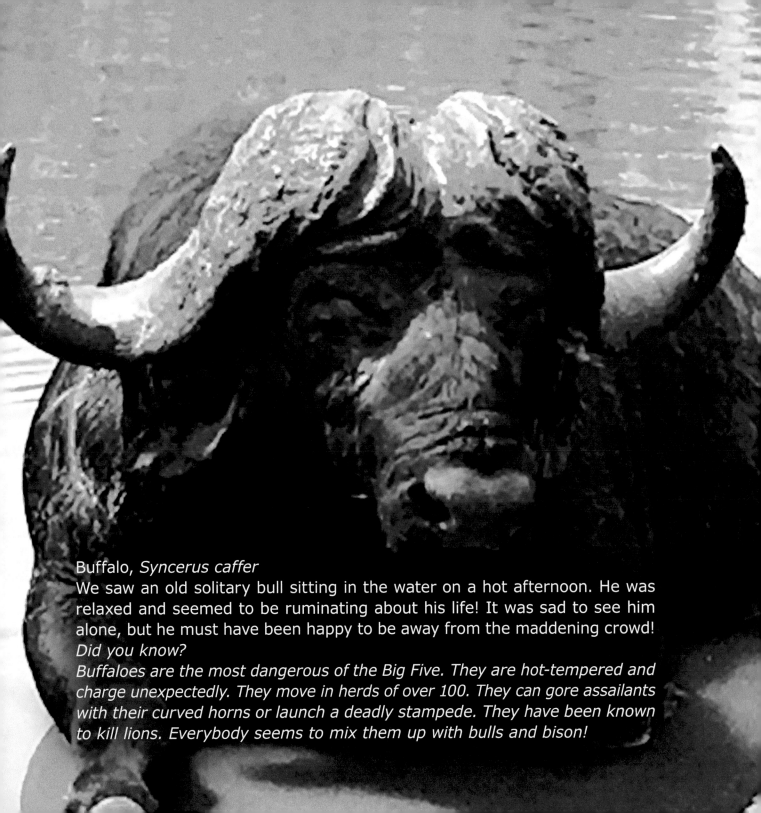

Buffalo, *Syncerus caffer*
We saw an old solitary bull sitting in the water on a hot afternoon. He was relaxed and seemed to be ruminating about his life! It was sad to see him alone, but he must have been happy to be away from the maddening crowd!
Did you know?
Buffaloes are the most dangerous of the Big Five. They are hot-tempered and charge unexpectedly. They move in herds of over 100. They can gore assailants with their curved horns or launch a deadly stampede. They have been known to kill lions. Everybody seems to mix them up with bulls and bison!

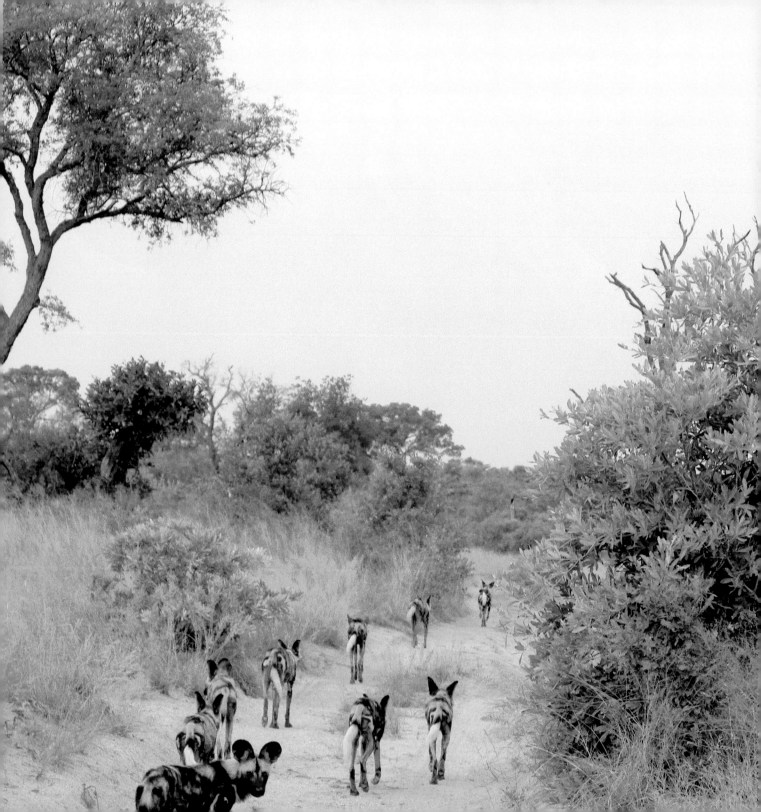

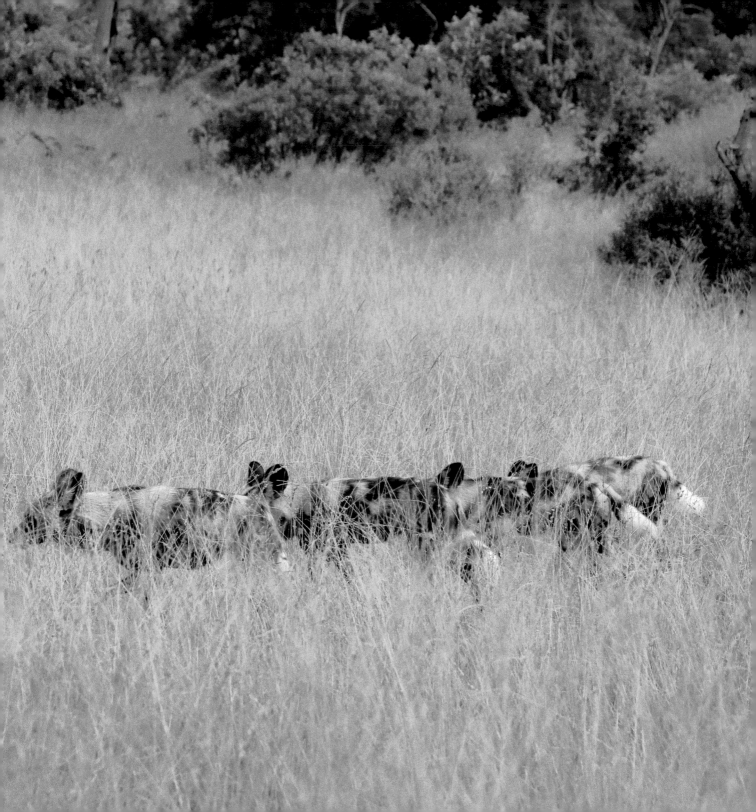

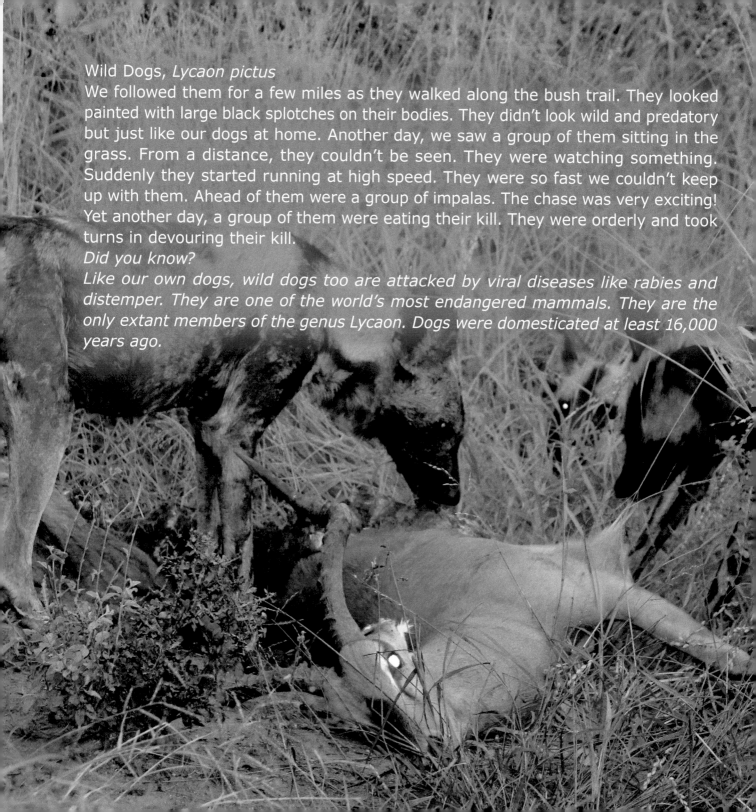

Wild Dogs, *Lycaon pictus*

We followed them for a few miles as they walked along the bush trail. They looked painted with large black splotches on their bodies. They didn't look wild and predatory but just like our dogs at home. Another day, we saw a group of them sitting in the grass. From a distance, they couldn't be seen. They were watching something. Suddenly they started running at high speed. They were so fast we couldn't keep up with them. Ahead of them were a group of impalas. The chase was very exciting! Yet another day, a group of them were eating their kill. They were orderly and took turns in devouring their kill.

Did you know?

Like our own dogs, wild dogs too are attacked by viral diseases like rabies and distemper. They are one of the world's most endangered mammals. They are the only extant members of the genus Lycaon. Dogs were domesticated at least 16,000 years ago.

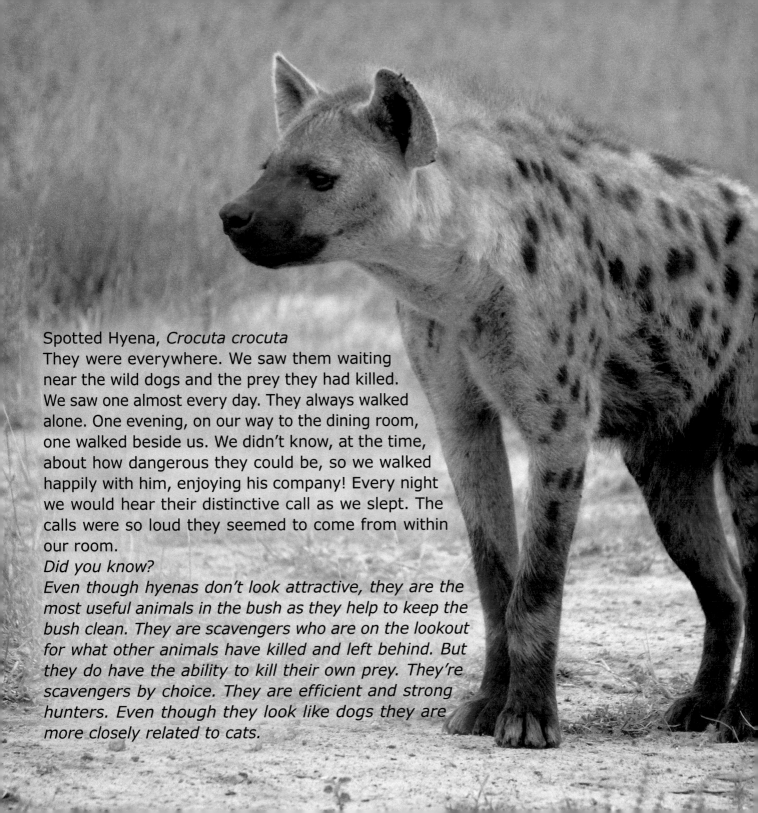

Spotted Hyena, *Crocuta crocuta*

They were everywhere. We saw them waiting near the wild dogs and the prey they had killed. We saw one almost every day. They always walked alone. One evening, on our way to the dining room, one walked beside us. We didn't know, at the time, about how dangerous they could be, so we walked happily with him, enjoying his company! Every night we would hear their distinctive call as we slept. The calls were so loud they seemed to come from within our room.

Did you know?

Even though hyenas don't look attractive, they are the most useful animals in the bush as they help to keep the bush clean. They are scavengers who are on the lookout for what other animals have killed and left behind. But they do have the ability to kill their own prey. They're scavengers by choice. They are efficient and strong hunters. Even though they look like dogs they are more closely related to cats.

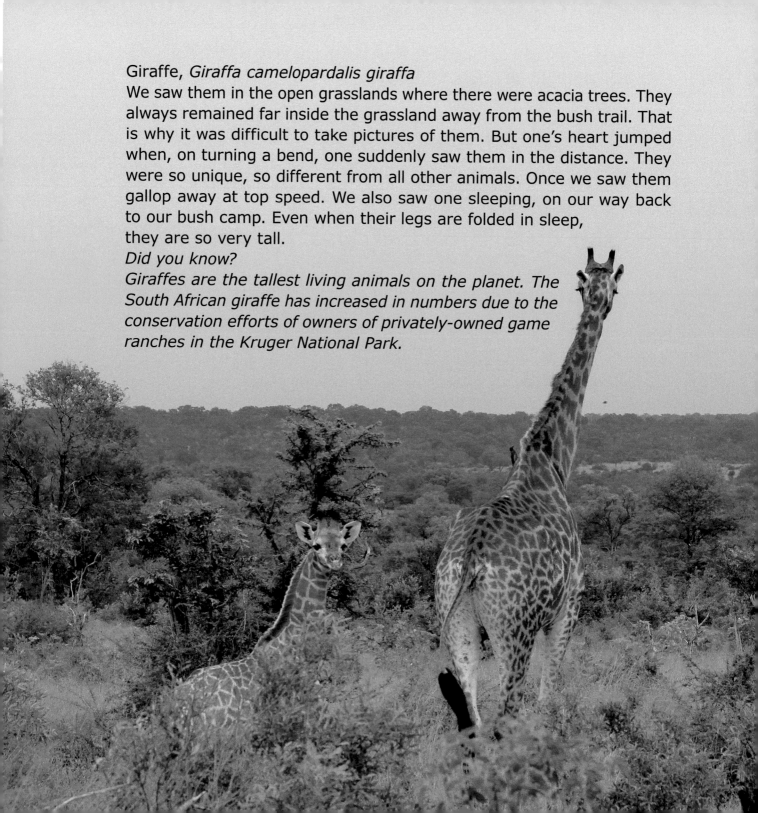

Giraffe, *Giraffa camelopardalis giraffa*
We saw them in the open grasslands where there were acacia trees. They always remained far inside the grassland away from the bush trail. That is why it was difficult to take pictures of them. But one's heart jumped when, on turning a bend, one suddenly saw them in the distance. They were so unique, so different from all other animals. Once we saw them gallop away at top speed. We also saw one sleeping, on our way back to our bush camp. Even when their legs are folded in sleep, they are so very tall.

Did you know?
Giraffes are the tallest living animals on the planet. The South African giraffe has increased in numbers due to the conservation efforts of owners of privately-owned game ranches in the Kruger National Park.

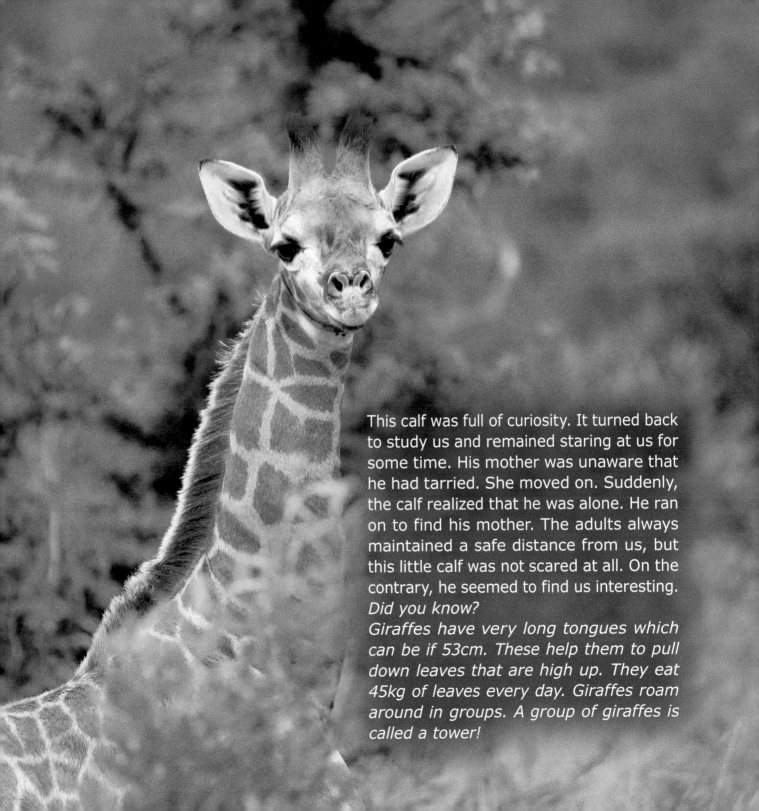

This calf was full of curiosity. It turned back to study us and remained staring at us for some time. His mother was unaware that he had tarried. She moved on. Suddenly, the calf realized that he was alone. He ran on to find his mother. The adults always maintained a safe distance from us, but this little calf was not scared at all. On the contrary, he seemed to find us interesting.

Did you know?

Giraffes have very long tongues which can be if 53cm. These help them to pull down leaves that are high up. They eat 45kg of leaves every day. Giraffes roam around in groups. A group of giraffes is called a tower!

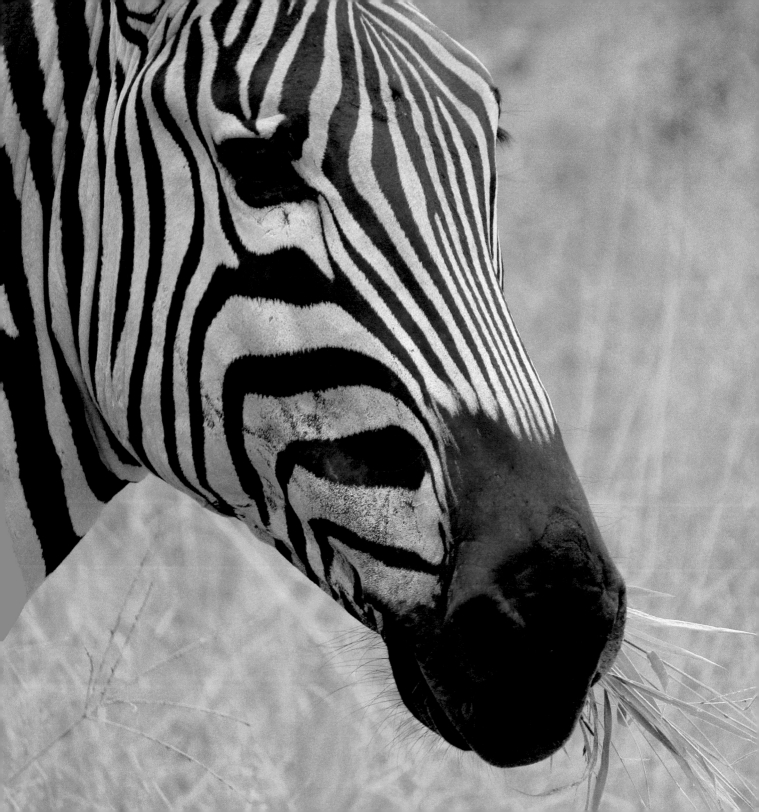

Zebra, *Equus burchelli*

They were startingly visible watching us carefully from a distance. It was difficult to click them up close as they scared easily. We saw zeals of them every day. They were present all over the bush. These were Burchell's zebra, one of the two species that are found in southern Africa. Often, we found them with giraffes. We saw many zebra foals too and they all had stripes like the adults. The foals were curious about us and looked at us intently. These natives of Africa fascinated us. Their stripes mesmerised us.

Did you know?

Zebras' strips are used to control their body temperature. They can raise the hairs on their black strips while the ones on the white ones lie flat. This helps in the transfer of heat cooling them down. It is thought that this could also deter flies from landing on them.

Debjani is a secondary school chemistry teacher. She has taught in Calcutta, India, Tashkent, Uzbekistan, Moscow, Russian Federation and in three different cities in The Netherlands finally setting up the science department of the International School, Almere. She is now an examiner of chemistry of a highly acclaimed international school leaving examination.

Debjani has been interested in photography since she was a young girl as her father and uncle were keen photographers. She has used many different cameras taking innumerable pictures over the years. Recently, she was fortunate enough to visit the Kruger National Park in South Africa where she saw and photographed animals living in the wild. She would like others to see and grow to love these animals who help to maintain our ecosystem.

Debjani had an exhibition of her photographs at the prestigious Academy of Fine Arts, Calcutta, India in July 2019. Her work was highly appreciated by all who visited the exhibition. She was overwhelmed with the response.

Debjani has loved animals from a young age. This photo book is her celebration of animals who live in the wild and of nature, the greatest of all teachers.

Contact
W: www.debjanisengupta.com
E: debjani.sengupta.nl@gmail.com

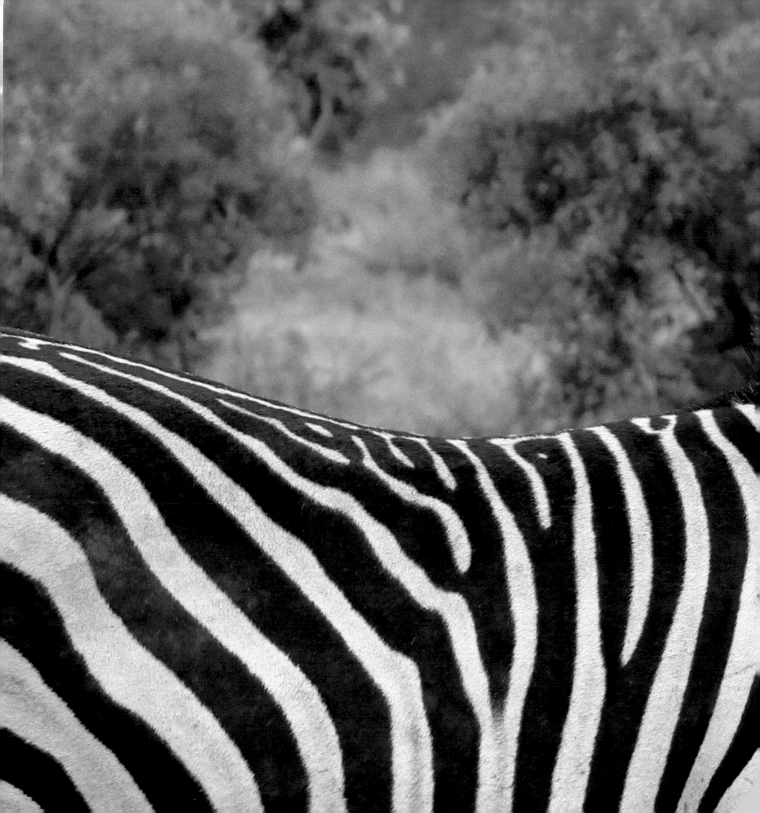

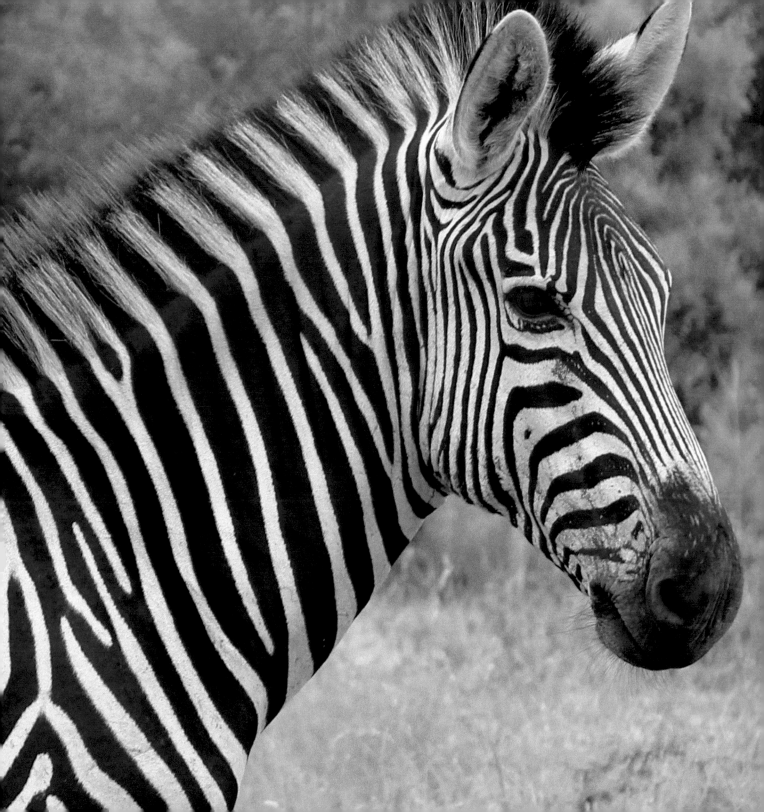

Printed in the United States
By Bookmasters